Her Majesty's Stationery Office

St Crispins
Duke Street
Norwich
NR3 1PD

Telephone 0603-69

Graphic Design

GD07

PRINTMAKING

Susan Lambert

Department of Prints, Drawings & Photographs
Victoria and Albert Museum

London
Her Majesty's Stationery Office

© Crown copyright 1983
First published 1983

ISBN 0 11 290381 9

Printed in the UK for HMSO

Dd 718102 C65

Contents

Acknowledgments

This booklet accompanies a display of printmaking techniques in the Victoria and Albert Museum. The display was first set up in 1903 by students at the Royal College of Art, where many of the teaching examples still on show were produced. It was prepared under the direction of Sir Frank Short, who also produced a descriptive manual. This initial display dealt solely with intaglio techniques. According to reprints of the manual this was still the case in 1910 and 1914 but, by the fourth edition published in 1925, the display had been expanded to include a section on water-colour prints from relief etched plates supplied by William Giles and another on offset lithography based on a gift from Harold Curwen. Since then the display has been expanded to include other forms of relief printing and lithography, and, more recently, to encompass the stencil processes and, in particular, screen printing.

In 1978 the gallery was reorganized with advice on its design from Paul Williams. The display has been recently adapted again with help from Brian Griggs and Richard Cottingham to suit its new location in The Henry Cole Wing. The approach to the subject has not, however, been changed radically since the gallery's inception. The descriptive labels on which this booklet is based draw heavily on those provided by Sir Frank Short, A. W. Ruffy of this department, who drafted a revision of the original manual during the 1950s, and all the other members of the department, and particularly Frank Dickinson, who have at some time produced labels for the display.

This booklet does not include the 'action' pictures shown in the gallery. Nevertheless I should like to thank Michael Rand, Roy Crossett, William Wood and Robert Tipper, all of the Royal College of Art, and also the wood-engraver, John Lawrence, and the fine art printers, Thomas Ross & Son Ltd., for their advice and their willingness to be photographed while working.

I should also like to thank Mark Haworth-Booth and Charles Newton for information on photo-mechanical techniques, John Lee and Sally Chappell for taking the photographs and Anthony Burton for editing the text.

Susan Lambert

Introduction

Printmaking is the craft of producing images by a variety of printing techniques. Before the invention of photography, printmaking with blocks, plates and stones worked by hand was the only means available of making exactly repeatable visual images on paper. This meant that prints were called upon to fulfil a wide range of educational, religious and propagandist functions and were used for utilitarian as much as aesthetic ends. Since photo-mechanical methods of reproduction have become available, printmaking has continued to develop as an independent art form, the different techniques being used for the particular qualities they give to an image.

This book aims to explain how prints are made and to give a brief history of the development of the different processes in order to add to the appreciation of their qualities rather than to supply a how-to-do-it guide. Much practical and scientific information essential to the successful production of prints is absent. This can be obtained from some of the books listed in the 'Technique' section of the bibliography.

The existence of relatively cheap paper was essential to the development of utilitarian printmaking and the kind of paper used to make a print has a considerable effect on the character of the impression. A knowledge of the development of paper manufacture can thus be a great help in understanding the art and, furthermore, in dating individual works. For these reasons paper making is also described briefly.

Most techniques of printmaking fall into one of four categories:

Relief processes:	Processes in which the ink is applied to raised surfaces.
Intaglio processes:	Processes in which the ink is held in grooves and hollows.
Planographic processes:	Processes which are based on the fact that grease and water repel one another, and have the inked surface level with the un-inked areas.
Stencil processes:	Processes in which the areas not to be printed are masked out.

The descriptions that follow take each category in turn, concentrating on its more traditional forms but an attempt is also made to show how these manual processes have been developed into the photo-mechanical techniques used by commercial printers and recently by artists too. Photographic techniques, such as those used in the family snap, that depend solely on the chemical action of light rather than the use of photographic principles to assist in the production of an image in ink, paint or carbon, are omitted. A selection of techniques that do not conform to the four main categories are described briefly at the end in alphabetical order. There is also a glossary of the terminology used in connection with prints and of the abbreviations found in inscriptions on them.

1. Paper

Manufacture

The way in which hand-made paper is produced has changed little since its inception and machine methods follow the hand procedure.

Paper consists of matted fibres. Fibres of the desired consistency are obtained by boiling and beating linen and cotton rags or other vegetable matter to a liquid pulp. It is made in a mould which looks much like a tray with a fine wire grid as its base. The sides of the mould, known as the deckle, are removable. The wire grid is made in two patterns and, depending on which is used, the paper is described as either 'laid' *(fig. 1)* or 'wove' *(fig. 2)*.

To make a sheet of paper by hand, the mould is dipped into the liquid pulp so that the wire grid is covered with the correct amount for the thickness of paper required. The mould is then shaken to make sure that the pulp is evenly distributed and that the fibres are well enmeshed. After much of the liquid has drained away, the deckle is removed and a piece of felt is pressed to the mould. The pulp forming the sheet of paper sticks to it, making removal from the mould possible. To extract the liquid further, a stack of such sheets is pressed, first with and then often without the felts in place. The sheets are then hung up to dry.

To obtain the required smoothness of surface texture the sheets are individually pressed, the pressure exerted being dictated by the desired finish. Traditionally, there are three grades of finish: hot-pressed, not (not hot-pressed) and rough. But within these grades a wide variety of effects can be obtained.

Hot-pressed paper is smooth. This surface is achieved by subjecting the sheets, placed between metal plates, to mechanical pressure. Not paper is also pressed in a mechanical press but without interleaving of any kind. Its surface bears, therefore, an imprint of the sheets above and

1
Beta-radiograph of a 'laid' paper with a watermark

The pale lines, which can be seen when the paper is held up to the light, are caused by the slight thinning of the paper where the pulp has rested on the wires of the mould.

The wire network of the mould in which laid paper is made consists of rows of thin wires lying close together known as 'laid' lines, crossed at intervals of 2.5–4 cm (1–$1\frac{1}{2}$ in) by thicker wires, known as 'chain' lines.

The watermark is created by lacing a filigree of wire to the network.

below it. Rough paper is not pressed at all, the stack of sheets and felts being left to dry out under their own weight. Its surface has a felt-like roughness.

Usually the paper is sized in order to make it harder and less absorbent. Unsized paper is known as water-leaf. Sizing is normally done before the final pressing takes place, by dipping the sheet into a vat containing a suitable glutinous substance. The finish and the absorbency of the paper used to make a print have a considerable influence on the character of the impression. For example India[1] paper, which is very thin and unsized and therefore very soft and absorbent, takes up a large quantity of ink without smudging, thus giving an unusually brilliant impression.

History

Paper was in use in China by the second century AD, but it was not manufactured in Europe until the twelfth century and only in the fifteenth did it supersede parchment (prepared from animal skins) as the standard material on which to write.

Until the end of the eighteenth century, all European-made paper was of the kind known as 'laid'. 'Wove' paper was introduced in the West about 1750 and was much praised for the increased smoothness this kind of mould gave. The first book containing 'wove' paper was John Baskerville's *Virgil*, published in 1757 but prints on this kind of paper seldom date from before the last decade of the century.

Until the end of the eighteenth century, all paper was made by hand and its dimensions were limited to the size of mould that could be handled by the craftsman. The first paper-making machine was invented about 1799. The paper was formed on a continuous woven wire mesh with its width limited only by that of the machine. In 1825, laid paper was first manufactured by machine.

Cotton fibre was the principal ingredient in all paper until the 1840s, when wood pulp was introduced. Paper made from wood pulp has a tendency to rot and to turn brown when exposed to light, as can be seen by the sad state of many nineteenth-century prints. Today this deterioration can, to a large extent, be counteracted by the use of chemicals, but the best quality papers are still manufactured from rags.

2
'Wove' paper held up to the light
As its name suggests, wove paper is made in a mould consisting of wire mesh woven much like a piece of fabric. When the paper is held up to the light, only an irregular mottling is visible.

1. True India paper is made in China. Presumably its name has arisen from its being imported by the East India Company.

2. Relief processes

In the relief processes the printing surface is raised above the areas which are to remain blank. The printing surface can be made of almost any material. Wood is the most common but potatoes, metal, lino, card, perspex and even found objects can be used. The surface is inked with a sticky ink, stiff enough to prevent it from flowing into the hollows. The ink is transferred to the paper by pressure. The printed image is in reverse of that on the printing surface. The lines of images printed by these processes are impressed a little beneath the surface of the paper and often show a build up of ink at their edges.

Relief processes are particularly suitable for book illustration. The printing block can be made the same thickness as movable type and locked with it in the printing press. This enables the text and illustrations to be printed on one sheet in one operation.

Woodcutting

Technique

In woodcutting the drawing is made on a smoothed block of relatively soft wood (such as pear, sycamore, cherry or beech) cut like a plank, lengthwise along the grain. The lines of the design are left untouched and the wood on either side of them is cleared away with a knife. Large areas are removed with chisels and gouges.

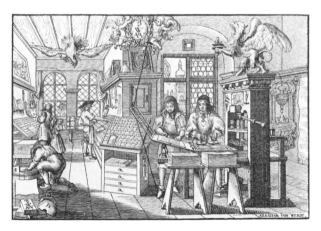

3
Abraham von Werdt (worked 1640–80), a relief printer's workshop
Woodcut

This woodcut shows a typical example of the kind of press in which relief prints are printed.

The man on the right is inking the type which lies on what is known as the 'chase'. He might equally well be inking a wood-block, or a wood-block and type locked together. The man beside him removes a sheet of paper which has just been printed from the 'tympan'. Hinged to the outer shield of the tympan is the 'frisket', which carries a paper shield which folds over the tympan and protects the margins of the sheet being printed. The paper shield is divided as for a quarto printing but inconsistently the pile of printed sheets in front of the press are printed as for a folio publication. To take a print, the tympan is loaded with a clean sheet of paper and, with the frisket closed, is folded over the inked type on the chase. Together they are pushed beneath the 'platen' which is screwed down on top of them, thus exerting vertical pressure.

On the left a sheet of paper is being dampened in preparation for printing and a pile of dampened sheets are stacked in front of the press. Damping the paper makes it more absorbent so that more ink is taken up, thereby giving a richer effect.

4
Edvard Munch
(1863–1944), The
Kiss, 1902
Woodcut, 47 × 47 cm,
E.5067–1960

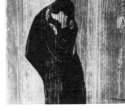

This print shows the
grain of the plank from
which it was printed
giving texture and
linear energy to what
would otherwise be a
large area of flat tone.
The grain of the wood-block can be heightened by
scraping the surface with a blade or rubbing it with
a wire brush.

An impression is taken by laying a sheet of
paper over the inked block and either rubbing the
back of it with a burnisher[2] by hand or putting the
block and paper in a printing press *(fig.3)*. Very
early woodcuts were printed in the same way as
textiles and wallpaper, by hammering the inked
block face down on a sheet of paper.

Colour woodcuts can be produced by two methods:

Separate blocks can be cut for each colour and be
printed one after the other on the same sheet of
paper.

The same block can be used for each colour by
printing the lighter tones first, and then cutting
these areas away before printing the middle tones
and so on, until only the areas to be printed in the
deepest colours remain in relief on the block. This
process is known as the reduce block method.

History

Woodcutting was the first technique to be used in
Europe for printing on paper. It was developed
from the practice of printing patterns on textiles
from wood-blocks.

The earliest woodcuts date from the end of the
fourteenth century. It has not been conclusively
proved where the technique was first used but
considerably more early woodcuts were made in
Germany and the Netherlands than elsewhere.
The earliest surviving examples are religious

2. Burnishers come in many different forms. Any
 implement with a curved smooth hard surface can be
 used.

pictures but playing cards are also thought to have
been mass produced by woodcutting at the same
period. With the invention of movable type in the
middle of the fifteenth century the history of the
woodcut becomes closely linked with that of the
printed book.

Block books are made up of sheets printed
entirely from wood-blocks, on which both the
text and the illustrations have been cut. Curiously
enough, they do not appear to have been
produced before the invention of movable type.
None of the existing examples can be dated before
about 1460. As the method was very laborious,
each letter being cut individually in the wood,
only very popular works, such as compendiums of
the Bible, were printed in this way. Few block
books were published after *c.* 1500.

Many early woodcuts were coloured by hand.
The first attempts at printing in colours were
made in the second half of the fifteenth century.
The earliest form to be used extensively is known
as the chiaroscuro method, which imitated the
current style of drawing in wash on toned paper
by printing a variety of tones of the same colour
from different blocks. Northern chiaroscuro
woodcuts tended to be conceived as an outline
(printed from one block) to which colours
(printed from other blocks) were added. Italian
examples *(fig.5)* tended to dispense with the

5
Ugo da Carpi (1450–1520), after a drawing
(specifically made for reproduction in this way) by
Pordenone (*c.*1485–1539), Saturn, this state
published in 1604
Chiaroscuro woodcut, printed from three blocks,
32 × 42.5 cm, E.284–1890.

outline and to present the composition purely in areas of tone.

The heyday of the woodcut was over by the end of the sixteenth century. Its place was taken increasingly, even in book illustrations, by the more sophisticated techniques of copperplate engraving and etching. At the end of the nineteenth century, interest in the medium was revived by artists such as Paul Gauguin, Edvard Munch *(fig. 4)* and the German Expressionists, who were attracted to it for specific effects the technique could give and by its inherent simplicity and directness.

Metal-cutting

The technique of metal-cutting *(fig. 6)* is similar to that of woodcutting, except that a plate of soft metal is used in place of wood. The lines are left in relief in the same way but areas of the metal are also left uncut. These are decorated with punched holes. The commonest punch had a round end producing white dots, which has led to the technique also being described as the 'dotted method'. Other shapes produced by punches include stars and fleur-de-lis. For printing, the plate is attached to a wooden block.

The first metal-cuts date from about 1430. After the invention of movable type the technique was, like woodcutting, widely used for the illustration of books.

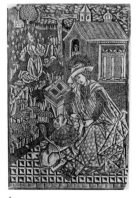

6
Anonymous, St Jerome, *c.* 1475–90
Metal-cut, 27.2 × 18.8 cm, British Museum.

Wood-engraving

Technique

The principal difference between wood-engraving and woodcutting is that in wood-engraving the drawing is made on a block of wood (usually hard wood such as box) cut across, rather than along, the grain. A block cut in this way has the advantage that it is less likely to splinter and can be cut cleanly with equal pressure in all directions. It can be worked, like a copper plate, with a burin, which is capable of achieving more delicate effects than the woodcutter's knife.

The fine lines cut by the burin are beneath the surface which carries the ink, and they therefore print white. This has led to many wood-engravings being conceived in terms of white lines on a black background and the technique is sometimes known as the 'white line method' *(figs. 7, 8)*.

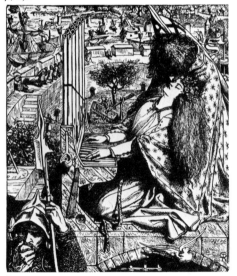

7
Dalziel Brothers after a drawing by Dante Gabriel Rossetti (1828–82), illustrating *The palace of art* by Alfred, Lord Tennyson, 1857
Wood-engraving in the black line method, 9.2 × 8 cm, E.29–1910

The scene is described by black lines. The wood is carefully cut away on either side of the lines which form the surface of the block and carry the ink.

Box trees are slow growing and their branches are seldom of sufficient diameter to produce large blocks. When large blocks are required they are made by bolting smaller ones together.

The drawing can be made either on the block or be transferred on to it. There are several ways of doing the latter. The drawing can be made on a sheet of paper and be traced on to the block with the aid of carbon paper. If transparent paper is used for the original drawing the printmaker can place it face down on the block and trace the image through the back. The resulting reversal of the drawing on the block has the advantage that the printed image is the same way round as the original. Drawings can also be transferred to the block photographically. This method, which came into general use in the 1860s, not only made the reversal of the image much easier but also allowed the reduction or enlargement of the drawing to the size of the block.

As the engraver works, he often rubs white chalk into the lines so that he can see more clearly how the work is progressing. The chalk is brushed out before the block is printed.

History

The first engraver to exploit fully the advantages of end-grain wood was Thomas Bewick (1753–1828) of Newcastle *(fig. 9)*. Once it had been proved that the technique could rival the fine effects of metal engraving, the advantages of wood-engraving to the book trade were quickly recognized. Allowing both text and illustration to be printed in one operation, it ousted the intaglio process as the favourite for book illustration and was only superseded at the end of the nineteenth century when methods of photographic reproduction were developed.

A school of wood-engravers working from their own drawings grew up around Bewick, but once this circle had dispersed few artists engraved their own designs. The rise in the level of literacy during the nineteenth century led to an increasing demand for illustrated books and magazines. The majority of the illustrations were wood-engraved facsimiles but many of these, such as those produced by the Dalziel Brothers *(fig. 7)* famous

for their engravings after the Pre-Raphaelites and the so-called illustrators of the sixties, translated the artists' drawings with relative freedom.

Much commercial wood-engraving was done by firms which employed large numbers of engravers. The bolting together of smaller blocks

8
Eric Ravilious (1903–42), illustration to *The hansom cab and the pigeons* by L. A. G. Strong, 1935
Wood-engraving cut in the white line method, 6.4 × 7.6 cm, E.556–1972

The shape of the train, its engine, buffers, wheels and windows are delineated by a white line. As with all relief processes, the ink is carried on the surface of the block but the line itself is engraved beneath the surface.

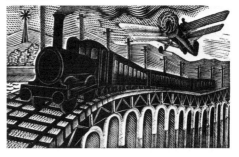

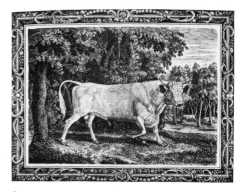

9
Thomas Bewick (1753–1828), The Chillingham Bull, 1789
Wood-engraving, 14 × 19.7 cm, 23539

The subtle gradations of tone in this wood-engraving are the result of Bewick's many technical innovations. By slightly lowering parts of the block, so that they received less pressure in the printing process, variations in the quantity of ink deposited on the paper were introduced.

to create larger ones was exploited to increase the speed with which the engravers worked. After the drawing had been made on the large block, its various sections were distributed to different engravers trained to work in the same style. When the engraved sections were reassembled, a master engraver worked over the joins *(fig. 10)*.

More impressions than the delicate block could stand up to were often required which led to the production of replicas, by electrotyping, a process discovered in 1839. Many so-called wood-engravings are in fact printed from electrotypes. To make an electrotype, a mould of the original block is produced by impressing it in wax or a synthetic equivalent. The mould is then chemically treated so that when it is immersed in a vat containing a solution of copper sulphate and subjected to an electric current, a thin layer of copper is deposited over it. This copper film, removed from the wax mould, faithfully reproduces all the indentations of the original block and backed with lead provides the printing surface. A number of electrotypes can be made from one wood-block, thus allowing a limitless number of impressions to be printed without fear of damaging the original block.

Only during this century has the technique been developed as an original graphic medium. Paul Nash, Eric Gill and Eric Ravilious *(fig.8)* are among artists who have used the technique.

Lino-cutting

This technique is a twentieth-century development of the woodcut with a sheet of linoleum substituted for the wood plank *(fig.11)*. As linoleum has no directional grain it can be worked with the engraver's tools as well as with those of the woodcutter. Being rather soft and crumbly however, it cannot produce fine lines.

Lino-cuts can be distinguished from woodcuts by their lack of wood graining, their characteristic spongy texture and, usually, by their lack of imprint.

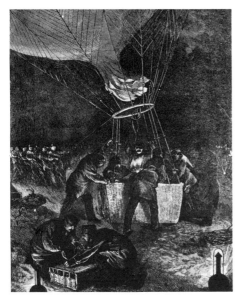

10
After **Arthur Boyd Houghton** (1836–75), illustration from the front page of *The Graphic*, Vol. III, 21 January 1871
Wood-engraving, 27.3 × 22.9cm, E.92–1976
The practice of bolting together small blocks to create a large block of end-grain wood was advantageous to commercial printers. By allowing them to divide the labour, it enabled them to produce large-scale pictures such as this at the speed required to depict news while it was still fresh.

11
Sybil Andrews (born 1898), Au Théâtre
Lino-cut, printed in blue, 23 × 27.8cm, Circ. 185–1929

Relief etching

Relief etching shares the same principles as the other relief processes but involves the use of different tools and materials. The design is made on a metal plate (originally copper but nowadays usually zinc), in fluid which is resistant to the corrosive action of acid. The areas around the design are eaten away by acid, leaving the lines in relief. William Blake experimented with printing in this way in *There is no natural religion*, published 1788–94. Subsequently these principles have become the basis of all photomechanical relief printing.

Line-block

The line-block is a photographic development of relief etching. A zinc plate is coated with light-sensitive gelatine and exposed to light through a high contrast black and white negative. The gelatine is washed away where it is unhardened. The remaining sticky gelatine is dusted with asphaltum which sticks to the lines of the image and, when heated, makes them resistant to the corrosive action of the acid. The plate is then etched and the lines of the design are left standing in relief.

The line-block, which was perfected by the early 1880s, can only be used for the reproduction of line drawings or flat areas with no intermediary tones *(fig. 12)*. Although black and white negatives are required to make the printing blocks, they can of course be printed in any colour. A separate block is required for each colour.

12
Aubrey Beardsley (1872–1898), Vignette to *Bon-Mots of Sydney Smith & Brinsley Sheridan*, 1893
Ink design with line-block and letterpress reproduction, images 4.8 × 4.8; 1.5 × 1.5 cm, E.335-1972
Beardsley was one of the first artists to make drawings specifically for reproduction by line-block, sometimes, as in this vignette, using the process to intensify the design by reducing its dimensions.

Half-tone letterpress

This is a development of the line-block, which came into general use in the 1880s, making it possible to reproduce tonal drawings. The original drawing is photographed through what is known as the 'screen', a fine network of crossed lines ruled on glass, which breaks up the drawing into evenly distributed dots of different sizes *(fig. 13)*. The lighter the tone, the smaller the dot, and the darker the tone, the larger the dot. The negative is printed on to a zinc or copper plate, which is developed and etched in the same way as in the line-block process. The dots are thus left in relief and form the printing surface. If a fine enough screen is used, an impression from the half-tone block gives the illusion of a continuous gradation of tone.

After the cross-line screen was perfected in the 1880s it was combined with a process of colour separation to make full-colour printing possible.

This colour process makes use of the fact that white light is composed of the three light primaries, red, green and blue.

Each of these primaries when mixed with one of the others produces a colour which is one of the pigment primaries. These colours (plus black) are those used in four-colour printing.

A coloured original is photographed through filters, which separate the areas to be printed by the respective primary colours, in order to make separation negatives from which separate half-tone letterpress plates are made for each colour. A red filter is used to make the negative for the cyan printing plate, a green filter to make the negative for the magenta plate, and a blue filter for the yellow plate. A fourth negative is photographed through a special amber filter to make a black printing plate, which adds strength to the darker areas of printing.

The printing areas are transferred from the negative to the plate photographically and these plates are then printed in succession, so that they overprint in register, to produce the completed work.

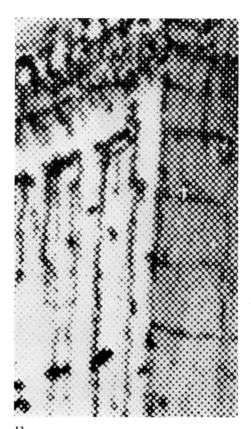

13
Enlarged detail showing the screen of a half-tone letterpress print

The dots produced by the screen vary in size according to the tone but their centres are always equidistant. In places the ink can be seen pressed to the edges of the dots as would be expected with a relief method.

3. Intaglio processes

In the intaglio processes the printing surface is sunk beneath the areas that are to remain blank. The ink is held in grooves or pits made on the plate. This is usually a highly polished metal sheet with bevelled edges, but celluloid, linoleum and even wood are among other materials which can be used.

Copper, the metal most frequently employed, came into general use around 1520, but iron, steel, brass, bronze and zinc are among others which have been employed at different times. Zinc plates began to be manufactured early in the nineteenth century. They are more frequently used for etching than engraving but being softer and coarser than copper they are inclined to etch with less reliable results. Steel plates came into fashion in the 1820s as a result of the demand for a plate which would yield a greater number of impressions than copper before showing signs of wear. They have the disadvantage that their hardness makes them very difficult to work. They have been little used since the end of the 1850s, when a method of steel-facing copper plates was invented. By electrolytically precipitating steel on to an etched or engraved copper plate, the printmaker can work on a soft copper plate, and then give it a hard-wearing surface which will stand up to long use, thus taking advantage of the tractability of the one material and the toughness of the other.

The intaglio processes can be subdivided into two categories:

Engraving, in which the grooves and pits are cut with a tool.

Etching, in which they are bitten by acid.

In both cases, ink is applied to the plate with a dabber or roller and forced into the grooves and pits. The surface of the plate is then wiped clean. Sometimes a very soft, fine muslin is drawn lightly over the plate so

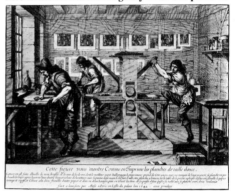

14
Abraham Bosse (1602–76), interior of an intaglio printer's shop, 1642
Etching

This print shows the various stages involved in printing an intaglio plate and includes an example of the kind of press in which such plates are printed. The method remains much the same today.

The figure in the background is shown applying ink to a plate with a dabber. In front of the window is a small grate on which the plate has been warmed in order to make the ink run more freely. The man on the left has finished cleaning ink off a plate with a muslin rag and is giving it a final wipe with the palm of his hand.

On the right is the press which exerts pressure by passing a sliding printing bed between two rollers, much like a mangle. Roller presses are used for intaglio printing in preference to screw and lever presses because they exert the required pressure more easily.

An impression is in the process of being taken. Before a sheet of paper is printed it is dampened to make it more pliable and absorbent. The plate and the sheet of paper, covered by a cushioning blanket, rest on a bed which is halfway through the rollers. Recently printed impressions are shown hanging up on the line to dry.

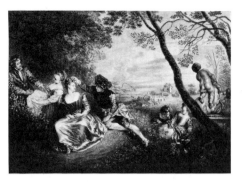

15
Benoît Audran (1698–1772) after Jean-Antoine
Watteau (1684–1721), Amusements Champêtres,
1735
Engraving and etching, 36 × 47 cm, 414/1874–1885

This print was produced at the request of Jean de
Julienne, who undertook to commemorate the
painter by having all his available works reproduced.

The French engravers of the eighteenth century
developed a method in which line engraving and
etching were combined to produce an effect
particularly in tune with the lighthearted quality of
their subjects. The landscape, the gentle movements
of the foliage and the subtle effects of the light are
rendered in the more malleable and softer medium
of etching but the glitter of the scene and the
shimmering of the costumes are interpreted with
sharp, clearly cut engraved lines.

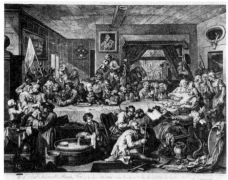

16
William Hogarth (1697–1764) after his own
painting now in Sir John Soane's Museum, London,
An Election Entertainment, Plate 1 from a set of
four, 3rd state, 1755
Etching and engraving, 43 × 55 cm, Forster 118(76)

The inscription 'Published 24th Febry, as the Act
directs' refers to the engraver's Copyright Act,
passed in 1735, in the creation of which Hogarth
played a leading part. The Act forbade the copying
of a print (without permission) for fourteen years
from the date of publication. A fine of one shilling
was imposed for every impression of a copy found.

that a small quantity of ink is drawn out of
the grooves in order to soften the printed
lines. This process is known as retroussage.

To take an impression, a sheet of paper is
laid on the inked plate and together they are
submitted to sufficient pressure (achieved
most easily in a roller press) to drive the
paper into the grooves so that it picks up the
ink *(fig. 14)*.

In images printed by these processes, the
paper bearing the ink is slightly raised. The
pressure of the plate smooths the grain of
the remaining surface and with its bevel
creates what is known as the 'plate-mark'.
The printed image is in reverse of that on the
plate. Intaglio processes are often used in
combination *(figs. 15, 16)*.

Corrections can be made to etched and
engraved plates (as long as they are not too

deeply etched or cut) by burnishing the
faulty areas and hammering them level with
the rest of the surface of the plate from
behind.

Colour intaglio printing

There are two traditional ways in which the
intaglio processes are printed in colours.

Each colour can be printed from a sep-
arate plate. With this method it is important
to ensure that the plates for each colour are
printed in register. To do this, small holes
are drilled through the top and bottom (and
sometimes the sides) of all the plates stac-
ked exactly on top of one another. The holes
on the first plate to be printed leave inden-
tations in the paper which act as a guide
when the sheet is placed face down on the

next plate. The printer pricks through the indentations lining them up with the holes in the plate to be printed.

Alternatively all the colours can be applied to a single plate and printed in one operation. The coloured inks, usually the darker tones first, are dabbed on with 'dollies' (rag balls on the end of a stick), great care being taken to ensure that the colours do not run together.

To these methods a third has recently been added. Developed by S. W. Hayter during the 1950s, it allows the same plate to be inked with all the colours, one on top of the other, and to be printed in one operation. The technique is dependent on the fact that inks of different viscosities are not inclined to mix. A thin layer of ink of low viscosity will reject a thick layer of ink of high viscosity applied to it, but if the ink of low viscosity is applied on the top of the highly viscous one, it will stick.

Line-engraving

Technique

The tool used in line-engraving is called a burin. It consists of a steel rod with a square or lozenge section, bevelled and sharpened at its tip. The handle of the burin is held firmly in the palm of the hand and the tool is pushed at an acute angle over the plate. Its tip cuts into the metal and removes a sliver which is lifted clear by the burin's bevel. Any ridge of rough metal which remains on either side of the line is removed with a scraper.

Engraved lines swell and taper according to the amount of metal that is removed, usually coming to a point at their tip *(fig. 17)*. Curved lines are engraved by turning the plate during the process of engraving.

17
Enlarged detail from a line engraving

Engraved lines are cleanly cut. Even under magnification their edges are sharply defined.

18
The Engraver, illustration to *Jack of All Trades*, 1805
Etching, V&A Library

The engraver is shown engraving a reproduction of the picture placed on the easel. The picture is reflected in a mirror in front of him. As the printed image is in reverse of that on the engraved surface, the engraver works from a reflection of the picture so that the composition will be the same way round in the print as in the original.

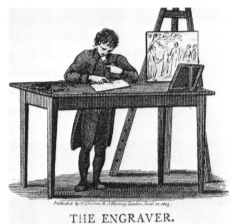

Publish'd by W.Darton & J.Harvey London June 12.1805.

THE ENGRAVER.

History

The engraving of lines in metal in order to print on paper developed from the goldsmith's long-established practice of decorating metal with engraved patterns. According to legend, printing on paper from metal blocks was discovered by a goldsmith. Leaving a nielloed plate to dry over night with a sheet of paper resting on it, he found in the morning that a bundle of wet clothes had been placed on top of it. The dampened paper had been pressed into the nielloed grooves, thus making a print.

The technique was first used for printing on paper in the second quarter of the fifteenth century. It arose independently in Germany and Italy, probably slightly earlier in Germany. To

19
Marcantonio Raimondi (c. 1480–c. 1534) after Raphael (1483–1520), Judgement of Paris
Line engraving, 29 × 43.5cm, Dyce 1036

Marcantonio was the first engraver to exploit engraving as a means of reproducing the work of other artists, and Raphael was the first great painter to recognize the advantages of popularizing his work in this way.

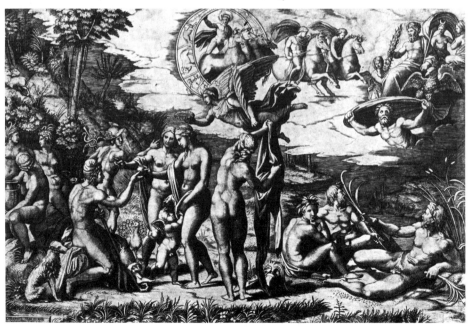

begin with, engraving fulfilled a dual purpose. It was a means both of original expression and of obtaining reproductions of paintings and duplicated images of all kinds. By the middle of the sixteenth century it had become predominantly a means of reproduction (fig.18). So it remained until photographic methods of reproduction were developed towards the end of the nineteenth century. Only then did interest in line engraving as an original graphic medium revive.

The multiplication of images through engraving had the result that iconographic and stylistic innovations in painting, sculpture and the decorative arts spread rapidly (fig.19). Engraved patterns and decorations were circulated expressly for the use of craftsmen, including goldsmiths, furniture makers, leather workers and embroiderers, and prints were collected by painters and sculptors to be referred to as models when a particular subject was commissioned.

20
Enlarged detail from a dry-point

This shows the un-inked spines often found between the central furrow of a dry-point line and the burr on either side of it.

Dry-point

Technique

In this technique the line is scratched on the plate by a tool with a sharp point. The tool is held in much the same way as a pencil and differs from the engraver's burin in that it pushes the excess metal to the sides of the furrow rather than lifting it clean away. It is this curl of rough metal known as the 'burr' which gives the dry-point its character (fig.20). The ink is retained in the burr as well as the furrows and gives the edges of the printed line a soft blurred quality. The burr is very delicate and even when the plate is steel-faced it soon gets worn away.

History

Although dry-point is a form of engraving, it is often used in conjunction with etching. There are examples of a plate being scratched in a way akin to dry-point as early as the fifteenth and sixteenth centuries and it was more widely used in the seventeenth century. It was particularly popular with Rembrandt. Nevertheless, dry-point did not become a popular printmaking tool until the invention of steel-facing in the middle of the nineteenth century made it possible to obtain more than a few high-quality prints from one plate (fig.21).

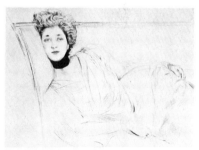

21
Paul César Helleu (1859–1927), Portrait of a Young Woman, Seated Wearing a Hat
Dry-point, 34.3 × 26.7 cm, E.153–1969

This print has been worked entirely with the dry-point. Where no burr is visible it has been removed with a scraper.

Mezzotint

Technique

The mezzotint is a form of tonal engraving and, because the engraver works from dark to light, is often described as a negative process. The plate is prepared so that it will print an even, deep black. This is done by systematically pitting its surface with a serrated chisel-like tool, known as a rocker, which raises a uniform burr. The design is formed by smoothing the burr so that different areas of the plate will hold different quantities of ink and therefore print different tones of grey. A scraper is used to remove large areas of burr and a burnisher for more delicate work. High lights are achieved by burnishing the plate quite smooth so that when it is wiped no ink remains on these areas *(fig. 22)*.

History

Mezzotint engraving was invented by an amateur artist, Ludwig von Siegen of Utrecht, in about 1640. But it was in England that the technique was perfected, becoming known on the Continent as the *manière anglaise*. Prince Rupert is said to have introduced it to England. He was a nephew of Charles I and grew up on the Continent where, according to tradition, he met von Siegen. Having settled in England in 1660, he demonstrated mezzotinting to John Evelyn, who made the technique public in his *Sculptura, or the history and art of chalcography and engraving in copper*, first published in 1662.

Mezzotint is particularly suited to reproducing the tonal gradations of paintings, and mezzotint reproductions did much to popularize the compositions of Gainsborough, Reynolds *(fig. 23)*, Joseph Wright, Romney and other artists working in the eighteenth-century. Only during the last few years has it been used at all widely as a medium for original expression.

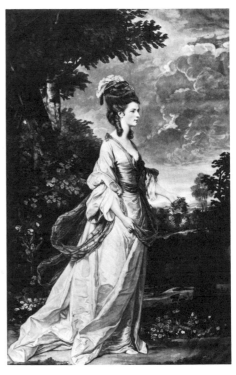

22
Sample of mezzotint from *Recueil de planches du dictionnaire des beaux-arts*, 1805
Showing the mechanical quality of the ground

23
Valentine Green, A.R.A. (1739–1813) after an oil painting by Sir Joshua Reynolds, P.R.A. (1723–92), Jane, Countess of Harrington
Mezzotint, 63.5 × 38.7 cm, E.122–1963

Etching

Technique

In etching the grooves and hollows are formed by the corroding action of acid, known as 'biting'.

First the plate is coated with a thin layer of wax-like substance, called the 'ground', which is impervious to acid.

Etching grounds are normally composed of beeswax, asphaltum, pitch and gum-mastic in varying combinations and proportions according to the purpose for which they are intended. The ground is applied by rubbing the block over the heated plate so that it melts on to it, and a dabber or roller is used to spread it. To make a liquid ground, the normal ingredients of an etching ground are dissolved in a volatile solvent such as chloroform or xylene. In this liquid form it is either painted or poured on to the plate. Liquid grounds are particularly useful for touching in areas that have been damaged or where mistakes have been made. Before the plate is drawn on, the ground is smoked with burning tapers to blacken it.

The design is made through the ground with a needle which lays bare the metal where the lines are required. Little pressure need be applied to the needle because there is no need for it to scratch the metal. When the design is complete, the back and edges of the plate are protected with varnish, and it is placed in a bath of acid diluted with water. The kind of acid and the proportion of acid to water varies according to the metal to be etched and the effect desired. Different etching needles can be used but the strength and thickness of a line is mainly dependent on how deeply it is bitten. The time required for the action to take place varies enormously. It can be as little as a minute or as much as two hours.

When the faintest lines have been sufficiently etched, the plate is removed from the acid so that the completed parts can be protected with varnish (known as 'stopping out') before biting continues for the darker ones. This procedure can be repeated any number of times until the deepest lines have been etched. If the acid etches through

24
Enlarged detail from an etching

Etched lines are softer than engraved lines and move more freely. The softness is caused by the uneven action of the acid on the granular structure of the metal. The freedom is a result of the etching ground offering little resistance to the needle, allowing it to draw with almost the same ease as a pencil, whereas the engraver's burin has to dig through the metal of the plate.

faults in the ground it is described as 'foul biting'.

Before the plate can be printed the ground and varnish are removed. If a proof shows that the plate requires additional etching, a new ground must be laid. Usually this is not smoked so that the etched lines remain visible. It is important that the ground is rubbed well into the lines already bitten, in order to prevent them being further acted on by the acid.

Exposed metal is uniformly etched to the same degree. For this reason an etched line tends to be the same thickness throughout its length and to have, in comparison with an engraved line, a blunt end *(fig. 24)*.

History

The technique of etching was developed by armourers as a method of decorating weapons, and it was not used for printing on paper until shortly after 1500 in Germany *(fig. 25)*. To begin with it was viewed as a labour saving method of line engraving, and a hard ground, which offered some resistance to the needle, was used. Not until early in the seventeenth century was the freedom the technique allows fully exploited. Since then most painters have tried their hands at etching and some artists have made their name through their work in this medium *(fig. 26)*. Etching, often in conjunction with engraving, has also been used as a method of reproduction *(fig. 15)* and as a means by which the artist can produce an outline for professional aquatinters and hand colourists.

26
James McNeill Whistler (1834–1903), The Piazetta from 'Venice, a series of twelve etchings', 1880
Etching, 25.3 × 17.8cm, E.3042–1931

Whistler was one of the first artists to put his pencilled signature to a print, a practice that grew up during the second half of the nineteenth century in order to distinguish works printed from surfaces made by the artist and reproductions of work in other media.

Margins beyond the plate-mark are rarely found on Old Master prints and this has lead to the supposition that they were cut off before publication. Nevertheless, Whistler was unusual in the nineteenth century in choosing to trim his later prints to the plate-mark, only leaving a tag for his signature.

25
Albrecht Dürer (1471–1528), The Cannon, 1518
Etching from an iron plate,
21.7 × 32.4cm, E.579–1940

The earliest etchings were made on steel or iron, the materials with which armourers were accustomed to work.

Dürer made a total of five etchings, working in each case on an iron plate.

The use of an iron plate can be detected by the rough edges of the lines, a result of iron being a less uniform material than copper, and therefore biting less evenly. Iron has the disadvantage that it rusts.

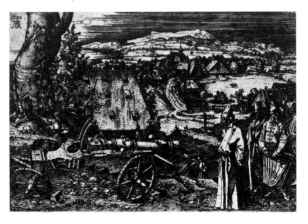

Soft ground etching

This is a method of etching developed towards the end of the eighteenth century, with which the effect of a pencil drawing or any other texture can be imitated.

As the name suggests, it differs from ordinary etching in the recipe for the ground, which by the addition of tallow is made considerably more impressionable. In the past, the ground was wrapped in silk so that any gritty impurities that might scratch the plate would be strained out. Reliable commercial preparations have made this unnecessary. The drawing is made with a pencil on a sheet of thin paper laid on the ground. When it is finished the paper is peeled back, picking the wax off with it in a broken line which corresponds to the graining of the paper, the hardness of the pencil and the pressure applied. The plate is then bitten in the same way as ordinary etching.

The effect of different textures can be achieved by impressing, for example, leaves, feathers, lace or pieces of crumpled paper in the ground. When they are removed they leave an impression of themselves which can then be bitten.

Aquatint

Technique

Aquatint is a method of etching in tone. The key to the technique lies in the application of a porous ground consisting of particles of finely powdered asphaltum or resin. The acid contacts the plate where it is unprotected between the particles, thereby etching pits in the metal which give a grainy texture when printed.

The tone of any part of the printed image is dependent on the depth to which the pits are etched, so the design is built up in stages by stopping out areas once they have been adequately bitten. Before the plate has any contact with the acid those areas which are to remain blank in the impression and must therefore have no pits to catch the ink, are stopped out. The plate

is then immersed in the acid. Once it has been sufficiently etched for the lightest areas, these too are protected with a coat of varnish. The process is repeated until the deepest tones have been bitten.

Continuous gradations of tone cannot be achieved with pure aquatint *(fig. 27)*. After the plate has been etched and the ground and varnish removed, however, the flat tonal areas can be modified by the use of a burnisher in the same way as in mezzotint.

The ground is usually applied by shaking up the dust in a dusting box and, after the coarser

27
Enlarged detail from an aquatint

Showing the irregular grain and flat ungraduated areas of tone characteristic of the medium.

particles have settled, inserting the plate so that a fine dust is deposited on it. Afterwards, the plate is heated gently so that the dust melts and clings to it to form the ground. The ground can also be laid by puffing the dust through a muslin bag, but laid in this way it is coarser than one applied in a dusting box.

Paul Sandby (1730–1809) pioneered the use of a spirit ground. In this method the resin was dissolved in spirit and poured or painted on to the warmed plate, the spirit quickly evaporating. The advantage of this method was that it allowed the artist to make spontaneous marks with his brush. Nevertheless, he still had to stop out the areas surrounding the freely drawn design to prevent them being etched.

A refinement of the aquatint, which avoids the laborious process of stopping out and therefore allows the printmaker greater spontaneity, is known as sugar aquatint *(fig. 28)*.

The design is made directly on the plate with a pen or brush, in a coloured solution in which is dissolved a large lump of sugar. When the solution has dried the whole plate is given a thin coat of varnish. The plate is then immersed in water, which slowly dissolves the sugar, causing it to swell and dislodge the varnish, thereby exposing the bare metal underneath. An ordinary aquatint ground is then applied to the plate, which can be bitten in the normal way. The process can be repeated to obtain the different tones.

Some aquatinters prefer to paint the design in the sugar solution over the aquatint ground and then varnish it. When the varnish flakes off in the subsequent immersion, the underlying aquatint ground remains intact.

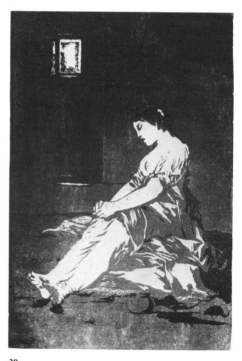

28
Pablo Picasso (1881–1973), illustration to Buffon's *Histoire naturelle*, 1942
Sugar aquatint, image 32 × 22 cm, E.222–1947

The brush strokes that applied the sugar solution are clearly visible. Such a calligraphic effect could never be achieved by stopping out.

29
Francisco Goya (1746–1828), plate from *Los Caprichos*, first published 1803
Aquatint, image 17.2 × 12 cm, E.2932–1902

This print is executed entirely in aquatint. More commonly, aquatint is accompanied by etched outlines and hatchings.

History

The characteristic grain of aquatint has been found on prints produced as early as the mid-seventeenth century but the technique was not fully developed until a century later. In 1768 a patent was taken out by Jean Baptiste Le Prince (1733–81) for a powdered resin ground. He described his method as the 'manière au lavis'. The term 'aquatint' was introduced by Paul Sandby (1730–1809) who was one of the principal British pioneers.

Aquatint, printed in sepia or colours, or coloured by hand, was much used to reproduce wash drawings and water-colours. With the exception of Goya (1746–1828), few artists used the medium for original graphic expression until late in the nineteenth century (fig. 29).

Stipple engraving

Technique

A method of rendering tones with dots and short flicks which involves a mixture of engraving and etching.

The plate is prepared with a normal etching ground. The contours and planes of the design are dotted through the ground with an etching needle and then bitten with acid. These pits are added to and sharpened by a burin used directly on the metal.

History

Pure stipple engraving was not practised until the middle of the eighteenth century but, before this, some engravers, such as Ottavio Leoni (1578–1630), obtained their delicate modelling by short flicks and dots in a manner anticipating stipple. Essentially a means of reproduction, the technique was used for all kinds of subjects, including portraits. It was particularly popular for light-hearted mythological, classical and pastoral themes, many of which were drawn specifically for multiplication by the technique. Stipple was little used outside England, where Francesco

Bartolozzi (fig. 30), an Italian who settled in London in 1764, was its most fashionable exponent.

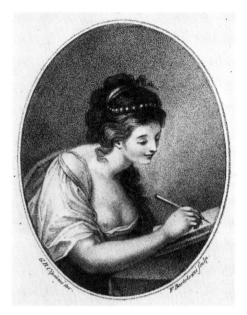

30
Francesco Bartolozzi (1728–1815) after
G. B. Cipriani (1726–85), Attention, 1798
Stipple engraving, image 10 × 7.8 cm, 26576

Etching in the crayon manner

Technique

This process imitates the appearance of a chalk drawing. It is closely allied to stipple engraving and is often used in conjunction with it. It involves the same mixture of etching and engraving but the marks through the ground and directly on the plate, are made with a variety of small toothed maces and roulettes rather than with a burin.

History

The crayon manner was invented in France around the middle of the eighteenth century

where it was used to reproduce the red chalk drawings of Boucher *(fig. 31)*, Fragonard and others. The technique was also popular in England. By the early nineteenth century it was displaced by lithography as a means of reproducing chalk drawings but continued to be used as an accompaniment to other forms of engraving.

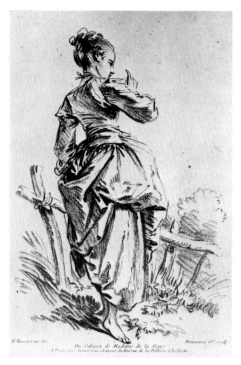

31
Gilles Demarteau (1722–76), after a drawing by François Boucher (1704–70), Shepherdess
Etching in the crayon manner, 19.2 × 13.2 cm,
29973.3

The method is a result of the discovery that light-sensitized gelatine hardens and becomes insoluble in water in proportion to the amount of light which falls on it. The image is printed on to the gelatine which is then attached to the plate usually prepared with a fine aquatint ground. The ground is not essential for line images.

To develop the plate, it is immersed in warm water, which causes the unhardened gelatine to dissolve, leaving a layered negative. The gelatine is thinnest in the areas which are to print the darkest, and thickest where least ink is required. When the plate is immersed in etching fluid, the acid bites quickest through the gelatine to reach the plate where the gelatine is thinnest and therefore etches these areas deeper than where the gelatine is thicker. The resulting plate, when it has been removed from the acid, is etched in gradations of depth according to the different thicknesses of ink required to reproduce the continuous varying gradations of tone of the original.

History

The technique, invented in 1869, was widely in use by the 1880s for the reproduction of paintings *(fig. 32)* and Old Master prints and drawings. With it, it is possible to make extremely deceptive reproductions of prints produced by manual processes, the reproductions being distinguishable only by the slight fuzziness of their line. The development of photogravure caused panic amongst the reproductive printmakers whom it made redundant, but it left printmaking, and in particular engraving, free to develop anew as a means of original expression.

Hand photogravure

Technique

Hand photogravure, sometimes called 'heliogravure', is a process by which a line or tonal image can be transferred photographically to a metal plate in such a way that it can be etched in one operation without stopping out by hand.

Machine photogravure

The same principles apply to machine photogravure as to hand photogravure. The difference lies in the way the graining, which enables the plate to hold the ink, is achieved. In hand photogravure, grain is provided by the aquatint

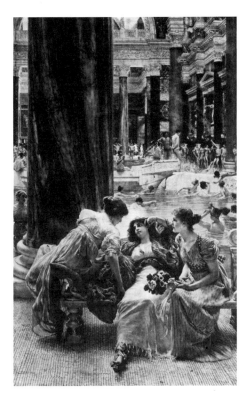

32
After an oil painting by **Sir Lawrence Alma-Tadema**, OM, RA (1836–1912), The Baths of Caracalla, 1900
Photogravure, 76.8 × 51 cm, E.175–1970

During the nineteenth century the demand for large reproductions of popular paintings increased enormously. The technical virtuosity of the engravers reached a peak but interest in engraving for its own sake faded. The introduction of photogravure provided a method of reproduction that was in some ways more accurate and in which the time-consuming labour of the engraver was replaced by the quick operation of the camera. Being an intaglio process requiring etching, it was still possible for the engraver to touch up the plate if required. In this print the background has been strengthened by marks applied by hand with a roulette.

ground, while in the machine process it is in the form of lattice work printed on the gelatine. Known as the 'screen', it has the added advantage that it gives the doctor blade, which removes the excess ink, a level surface over which to scrape.

The screen can usually be detected with the aid of a magnifying glass. The square dots it produces are all the same size unlike the dots in the half-tone letterpress process. The variation in tone is achieved by the varying thickness of the ink rather than by the size of the dot.

A flat-bed press can be used to print this technique but it is generally printed from a cylinder in a rotary press. This method allows an enormous number of impressions to be printed at great speed. As the quality of the image is reasonably good even on cheap paper, the process is much used in commercial printing for large runs of magazines, catalogues etc.

After the cross line screen was perfected in the 1880s it was combined with a process of colour separation to make full colour photogravure printing possible. Plates are made as for ordinary screened photogravure but colour filters are interposed to make separate plates for each colour. The filter process is the same as that described on p. 16 in connection with colour letterpress printing. The three primary colours are used in a series of over-printings to build up all the colours in the spectrum and a plate inked in black is also usually printed to add strength to the shadows. A large number of fine illustrated books, with reproductions of water-colours by artists such as Rackham and Dulac, were printed in the first decade of the twentieth century as a direct result of these developments.

Photo-etching

The technique of photo-etching is closely related to that of photogravure but the term is usually applied to its use as a medium for original expression rather than as a method of reproduction.

4. Planographic processes

These processes depend on the simple fact that grease and water do not mix. The printing surface is neither raised above nor sunk below the areas to remain blank, but is level with them. The printing areas are impregnated with grease and the blank ones moistened so that when greasy ink is applied to the printing surface it clings to the greasy areas but is repelled by the wet ones. The ink is transferred from the printing surface to the paper by pressure.

Lithography

Technique

In lithography the design is drawn or painted on the printing surface, traditionally stone but now more often a metal plate, such as zinc or aluminium, in precisely the same way as on paper. The surface must be of a kind that readily absorbs grease and water equally.

The drawing substance must be greasy. Lithographic chalk is made of a mixture of greasy substances (wax, tallow and soap), lamp black, and shellac. The lamp black provides the colour so that the artist can see what he is drawing and the shellac makes the chalk strong enough to be sharpened to a point and to stand up to the pressure exerted by the weight of the hand. The chalks, as with pencils, are graded according to their degree of hardness. Lithographic ink consists of the same ingredients dissolved in distilled water. The same kind of pen as is used to draw with indian ink is used to draw on the printing surface with litho ink. If the ink is considerably thinned and applied with a brush, an effect of wash can be achieved.

Once the drawing is made it is fixed in the printing surface. This is done by sponging the stone or plate with a solution of gum arabic (a water soluble resin) and a small amount of acid (not strong enough to eat into the printing surface) known as the 'etch'. The gum arabic protects the surface from any further grease with which it might come into contact, while the acid opens up its pores so that the gum arabic can penetrate. The etch also breaks down the soap in the drawing chalk, encouraging the fatty acids to sink into the printing surface.

Before ink is applied for printing, the surface is moistened, and, as grease and water do not combine, the parts already drawn upon repel the water and the untouched parts absorb it. A roller charged with a stiff greasy ink is passed over the surface. The wet parts reject the ink while the greasy parts (that is those parts which have been drawn upon with greasy substance) attract it. The paper is placed on the surface and together they are passed through a press.

The essential characteristics of a lithographic press are a movable bed on which the printing surface rests and an instrument to exert the pressure, known as a scraper. The scraper normally consists of a blunt wooden blade with its edge covered in leather (fig. 33).

To take an impression, the paper is laid on the stone or plate. Its back is protected with some spare sheets of packing paper topped by a tympan, usually made of brass or zinc. The scraper with its edge greased with tallow, is lowered on to the tympan pressing down on the edge of the printing surface. The stone or plate is then cranked under it from one edge to the other.

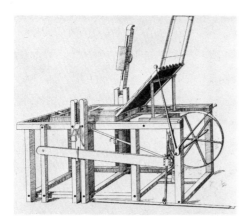

The print produced is a copy in reverse of the drawing on the stone.

The printing surface has to be re-dampened and inked for each impression. The same slab of stone can be used again and again for different designs, the old one being ground off. Sand calibrated according to grain size is used to grind down the surface. A very smooth finish is required for transfer lithography and for pen lithography but a slightly rougher surface is better for working with chalk or litho ink wash.

To make a colour lithograph a separate printing surface is required for each colour. An outline drawing of the original (made in a non-greasy substance which will not pick up the printing ink) is transferred to each stone or plate to act as a guide to the lithographer. Sometimes separate tracings are made for each colour. The elements corresponding to each colour in the design are then drawn on the stones or plates in the normal way, which are then inked with the appropriate colours. There are three ways of ensuring that the different colours are printed in register.

Small crosses in the margins can be carefully aligned as each surface is printed:

Small indentations can be drilled in the printing surfaces so that by passing a needle through the same hole in the paper into the different stones or plates, the sheet will be placed in exactly the right position.

If the design does not go to the edge of the stone or plate, corner and side marks can be made on it against which the edge of the paper can be aligned.

History

Lithography was invented by Aloys Senefelder (1771–1834), an actor and playwright, in 1798. His interest in printing stemmed from a desire to find a cheaper method to print his own writings than those available at the time.

In his first experiments with printing from stone he wrote on the surface with a greasy acid-resistant ink and then etched the stone, with the result that the text was left standing in relief. In 1798 he discovered how to print from the flat surface of the stone, the beginning of true lithography.

During the next few years, in partnership with the music printing family of André, Senefelder took out patents for his invention in most of the European capitals. In 1818 his treatise, *A complete course of lithography* was published in German, followed the next year by French and English editions.

Although the discovery of lithography was the result of economic pressures, Senefelder was quick to recognize its potential as a medium for fine art. The first portfolio of lithographs drawn by artists was published by Phillippe André in England in 1803. Entitled *Specimens of Polyautography*, it consisted of twelve pen lithographs by artists such as Benjamin West, Richard Corbould, James Barry, Thomas Stothard and Fuseli *(fig.34)*. Nevertheless, leading artists treated the new technique with a certain amount of suspicion. Goya, Géricault and Delacroix all made lithographs but it was in the popular press that the medium thrived, with Daumier as its most brilliant exponent *(fig.35)*.

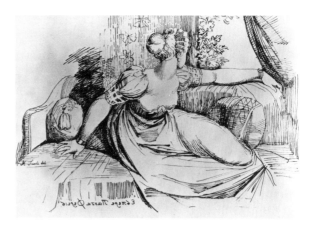

34
Henry Fuseli (1741–1825), a Woman
Sitting by the Window, from
Specimens of Polyautography, 1803
Lithograph, 22.2 × 31.8 cm,
E.3028–1948

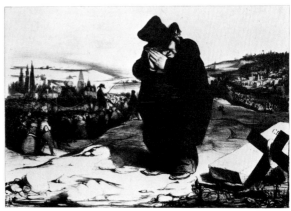

35
Honoré Daumier (1810–79), Enfoncé
Lafayette ... Attrappe, mon vieux!, 1834
Lithograph, 29 × 42 cm, Circ. 135–1951

Full colour lithography, as a means of repro-
ducing paintings, was in use from about 1820.
The first artist to use the technique as an original
art form was Thomas Shotter Boys, whose
portfolio of *Picturesque Architecture in Paris,
Ghent, Antwerp, Rouen etc. ...* came out in 1839.
It was not, however, until the 1880s that colour
lithography took root, popularized by the posters
of Chéret, and then Toulouse-Lautrec. A flurry
of periodicals devoted exclusively to the medium
came into existence and enterprising publishers
commissioned prints from artists for publication
in lithographic portfolios.

The technique continues to be used widely
both as a medium for original graphic expression
and as a method of commercial printing.

Transfer lithography

By a process known as transfer lithography the
artist can make his design on paper and then
transfer it to the printing surface. This method
has the advantage that he does not have to cope
with the cumbersome stones and plates himself or
allow for the reversal of the drawn image.

The drawing is made in lithographic chalk or
ink on transfer paper, the surface of which is
prepared so that it dissolves easily in water. To
make the transfer, the paper is thoroughly
dampened and laid face down on the printing
surface. Together, the paper sponged with water

frequently, they are then passed through the press several times. Gradually the paper soaks off, leaving the greasy drawing adhering to the printing surface. The preparation of the stone or plate and the printing process then proceed exactly as if the drawing had been made directly on the printing surface.

Transfers on to the printing surface can also be made from etchings, engravings, woodcuts etc. that have been printed in a specially prepared greasy ink.

The lines of a transfer lithograph tend to show the grain of the original paper rather than that of the stone.

A modern alternative to transfer paper is the diazo method. The artist draws on a slightly textured transparent film which allows him to work with whatever drawing implements he chooses, and through which the image is transferred photographically to a photo-sensitized aluminium lithographic plate.

Offset lithography

The design is prepared on the stone or plate in the normal way. The distinguishing feature of the technique is that the inked image is transferred on to a cylinder covered with a rubber blanket from which it is printed on to the paper. The image is therefore printed the same way round as it was drawn.

Prints of this kind can either be printed on an automatic flat-bed offset press (similar to the hand press except that the stone or plate is moistened and inked with power operated rollers) or in a rotary offset machine. Rotary offset machines came into use early in the twentieth century and are widely used in commercial printing. The image is carried by a metal plate which is fastened round a revolving cylinder thus a continuous rotary movement replaces the slow backwards and forwards movement of the flat-bed press. About 10,000 impressions an hour can be printed from a rotary machine.

Photolithography

Although lithographic stones can be prepared to receive photographic images, this technique is more often used in conjunction with metal plates. The negative is prepared in the same way as photographic line-block, half-tone and colour processes (see pp. 15–16). Tonal images can be broken up into a regular system of dots by being photographed through a network of crossed lines on glass. The image is then chemically transferred to the plate according to the principles of lithography, so that the areas to print dark attract the ink and the blank ones repel it. As with half-tone letterpress printing, the photolitho screen produces dots of varying size with equidistant centres. The techniques can be distinguished by the fact that the photolitho dots have soft edges while those printed by letterpress are sharply defined.

Collotype

Technique

Collotype is a photographic process in which a film of gelatine provides the printing surface. The technique depends on the fact that light-sensitive gelatine hardens in proportion to the amount of light to which it is exposed.

A solution of light-sensitive gelatine is poured over a sheet of plate glass. When it is dry the plate is placed in contact with the negative and exposed to light. The dark parts in the original image (light in the negative) cause the gelatine to harden and become impervious to moisture, while the light parts in the original (dark in the negative) remain soft and absorbent. When the printing ink is applied to the gelatine it is accepted in inverse

proportion to the amount of moisture the surface retains, the driest areas accepting most and therefore printing darkest. The printing surface is formed of a massing of tiny irregular crinkles created as the gelatine dries in the initial plate making process *(fig. 36)*. To print a collotype in colour a separate plate is required for each shade. Collotypes are often also coloured by stencil (see p. 35).

History

Collotype came into use in the 1870s. It has the advantage that it can render continuous gradations of tone without the intervention of a screen but the disadvantage that the plate can only yield about 2000 impressions. For these reasons collotype is usually only used for work where the accuracy of the tone is of special importance – in for instance, the reproduction of works of art.

Collotype has occasionally, as for example by Henry Moore in the 1940s and 1950s, been used as a medium for original expression. The negatives are created by hand by drawing on transparent sheets. This process is known as collograph.

36
Enlarged detail from a collotype, reproducing an etching, showing its grain

The puckered grain which distinguishes the collotype is caused by the surface of the gelatine which dries in wrinkles.

5. Stencil processes

The basic principle of these processes is that the surface which is to receive the design has the areas which are to remain blank protected from the pigment. This is done with a stencil.

Traditional stencils

As in all stencil techniques the purpose of the traditional stencil is to mask out the areas of the surface receiving the design that are to remain blank.

Anything from a hand to a banana skin can act as a stencil – its only requisite is that it should be impervious to the pigment – but the most common form of stencil is a thin sheet of metal or a piece of card from which the shapes of the design have been cut out *(fig.37,38)*. The stencil is laid over the surface to be painted and pigment is brushed or sprayed over it. A different stencil cut to the required shape has to be used for each colour.

Images produced by this method sometimes show a build-up of paint at their edges. This is caused by the brush depositing a little extra pigment as it pushes up over the stencil.

37
Copper stencil plate,
7.8 × 8.9 cm, E.185–1965

This stencil demonstrates one of the drawbacks of the traditional stencil which has been overcome by the screen print. 'Bridges' or 'ties' have to be left to hold unprinted islands in place.

38
Japanese paper and silk stencil, 31 × 41.3 cm,
D.1132–1891

The Japanese found a solution, not unlike that of the screen print, to the disfiguring ties of the traditional stencil. The central shapes are suspended on a network of silk threads securely pasted between two layers of the stencil.

History

The stencil process is thought to be the first method of duplication used by man. It was known to earlier civilizations, and has been in use in Europe for many centuries. Decorating walls and furniture, colouring prints, duplicating manuscripts, flocking wallpaper and printing on textiles have been and in some cases still are a few of its more common uses. In France (where it is described as 'pochoir') stencilling is particularly popular for the illustration of *éditions de luxe*.

Screen printing

Technique

Screen printing is a stencil process in which the stencil is affixed to a fine mesh of silk, man-made fibre, or steel, known as the 'screen'. The screen is stretched over an open frame. The ink is pushed across its surface by a flexible blade called a 'squeegee' and forced through the holes where the printing surface is not masked, on to the paper below.

A separate screen is required for each colour of the finished print. As in other processes, further colours can be produced by overprinting or by the optical mixture of coloured dots produced by a process camera. Using a method known as posterization, it is also possible to transform the subtle gradations in density of the tones of an original into several distinct steps of tonal density, without the use of a half-tone screen. At least three exposures of black-and-white film are used to obtain the various tones from light to dark within each of the customary three or four colour

separations of commercial practice. Thus the technique requires a minimum of twelve colour printings. Sometimes the texture of the mesh through which the ink has been squeezed can be seen on the surface of the screen print. But the only characteristic common to all prints produced by this process is that the ink rests on the surface of the paper rather than becoming part of it as, for instance, in the case of lithography.

Methods of producing the screen print stencil

The stencil can be cut or torn by hand from a sheet of paper; the stickiness of the printing ink and the suction produced by the printing action being sufficient to hold it in place on the screen. Alternatively, it can be cut from a transparent film specially prepared to adhere to the screen. This method has the advantage that it can be laid over the artwork for cutting.

Glue or lacquer can be painted directly on to the screen, stopping out the areas that are to remain blank. Alternatively, a related resist process in which every line drawn on the screen will produce a line in the finished print can be used to obtain more intricate effects. The design is printed on the screen in a greasy ink. Then the whole screen, including where it has been painted, is coated with a water-soluble glue. When the glue is dry, the back of the screen is wiped with spirit which dissolves the grease, causing the glue to flake off over the drawn areas while leaving it intact elsewhere.

The stencil can be produced photographically. Either a light-sensitized gelatine film, which is subsequently stuck to the screen, can be used or the screen itself can be impregnated with a light-sensitive emulsion. Both methods depend on the fact that light-sensitized gelatine hardens and therefore becomes impermeable in proportion to the amount of light to which it is exposed. Once the image has been developed on the light-sensitized surface the soft parts of the gelatine which correspond to where the ink is required to pass through the screen are washed away.

History

The screen print is a modern development of the stencil process. The first significant experiments in the medium were made early in the twentieth century. The medium, requiring little capital expenditure, soon became popular among sign makers and small advertising firms. It is used to print on many materials other than paper, including pottery, glass, plastic and metal.

Its potential as a fine art medium was first explored towards the end of the thirties when, under the auspices of the Works Progress Administration Federal Art Project, a screen printing unit with this aim was set up at the Reproduction Division of the USA Air Force,

39
Ronald B. Kitaj (born 1932), Acheson Go Home, 1963
Screen print, 73.1 × 53.1 cm, Circ. 198–1964

Screen printing with the aid of photography is used to integrate a diverse combination of images including newspaper cuttings, some torn paper, an engraving and a spot of real blood.

Larry Fields, Colorado. In an attempt to get away from the flat planes which had characterized most commercial work until then, the artists tried to achieve effects which imitated painting. To distinguish these prints from commercial work, they described them as serigraphs.

Few leading artists took up the process with enthusiasm until the 1960s, when they were attracted by its technical possibilities as much as by the quality of its surface. Some artists even began to screen print images in their paintings as well as using it as a multiple art form.

The flexibility of the medium has proved an attraction to artists working with photographic and collaged images *(fig. 39)*; the immaculate smooth planes of flat colour achieved with hand-cut stencils makes the technique a particularly suitable vehicle for hard-edge Op Art *(fig. 40)*.

40
Victor Vasarely (born 1908), Oeta–1956, from a set of ten entitled 'Album III Cinetique', 1959
Screen print in black and grey, 55.5 × 36.8 cm, Circ. 682–1965

This print has accompanying it a screen-printed design on transparent rhodoid film designed to be superimposed on the image that is reproduced and moved at will, giving infinite kinetic optical effects.

6. Hybrids and Oddities

Baxter process

The process, patented by George Baxter in 1835, combined the intaglio and relief printing methods. The foundation plate, which printed the main features of the design was etched (often through an aquatint ground) or stipple engraved, and oil colours were superimposed from wood blocks *(fig. 41)*.

41
George Baxter (1804–67), after V. Bartholomew, Hollyhocks, 1857
Baxter process, 37.5 × 27.2 cm, E.2963–1932

Carbon print

The process, perfected in 1864 by Sir Joseph Swan, consisted of a tissue of carbon impregnated gelatine being treated with potassium bichromate to make it light sensitive. The tissue, exposed under a negative, hardened in proportion to the intensity of light striking it. The tissue was transferred to a temporary support and the unhardened gelatine, where less light had passed through the negative, was washed away. The image was formed from the varying thickness of the dark gelatine: the thinner the tissue at any point, the lighter in tone. Superficially, carbon prints look like conventional photographic prints but they are not susceptible to fading because the carbon pigment is stable. The Autotype Co. took up Swan's process from 1866, using it to reproduce drawings and illustrations until the beginning of the twentieth century.

Carbon tissue was also adapted to form a light sensitive resist on the surface of photogravure plates. It is, therefore, theoretically possible that a carbon print could have been laid not on paper but on a printing plate to be etched to form the image.

Cliché verre

A photographic print made from a hand-drawn negative. To produce a cliché verre a design is scratched on a piece of smoked glass so that light will travel through where the soot has been removed. A piece of light-sensitized paper is placed underneath the glass and together they are exposed to light with the result that black lines

appear on the paper corresponding to where the design has been made.

This technique was first used by artists such as Corot and Millet in France in the 1850s and is, because of this association, usually classed as a printmaking process although no ink, paint or carbon are used to produce the final image. During the 1970s a school of cliché verre grew up at Detroit University, USA, and there are now pockets of artists throughout the United States practising the technique both in black and white, and in colour.

Collagraph

The term is derived from the French 'coller', to stick. It is a printing medium related to collage, which has come into use in this century among artists who wish to juxtapose varied textural effects in their work. The printing surface is made by sticking extraneous materials such as card, string, plastic, wire mesh etc. on to a backing. This irregular surface is inked and the image is formed from both the intaglio and relief surfaces.

Daguerreotype

A daguerreotype is made by the action of light on a highly polished silver plate treated with hot iodine before exposure. The latent image is developed with vapour of hot mercury. The resulting image is positive and very finely detailed. The process was first publicly demonstrated by L.J.M.Daguerre in 1839. Growing out of processes related to traditional forms of printmaking, it had a brief effective life, becoming obsolete before 1860.

The disadvantages of the process were that as the images were formed by minute pitting in the polished surface of the silver they could only be seen when the plates were held at an angle to catch the light; that the plates were fragile and that each daguerreotype was unique. In order to make a

replica, the whole process had to be done afresh. One solution found to these was to etch the plate. It was reasoned that the image of a daguerreotype was caused by chemicals attacking the surface of the metal plate and that this action could be accentuated in order to enable the plate to hold ink. With the aid of a professional engraver, Hippolyte Fizeau managed to etch and print several images from daguerreotypes. He also took electrotypes from daguerreotypes, from which prints could also be taken in ink.

Dye transfer

A method of producing a photographic print with greater colour density and more permanence than the normal emulsion process. The printing surfaces are formed by gelatine matrices, one for each colour separation. The matrices are immersed in dyes of the appropriate colours and printed in sequence, in exact register, on to specially prepared absorbent paper. The process is sometimes used to alter the colours of a conventional photograph.

Electrostatic printing (Xerography)

A copying process which uses electrostatic charges to deposit black or blends of cyan, magenta and yellow powder on to ordinary paper in proportion to the tone and colour of the image to be reproduced. Developed for commercial use, it has been taken up by artists. Assemblages arranged by the artist on the copying machine are reinterpreted and unified by the copying process.

42
Letter-heading, c.1840
Litho-engraving, image 9.5 × 18cm, E.880–1949

Glass colour printing

A glass colour print is made by thoroughly dampening an ordinary print, usually a mezzotint, and pasting it face down on to a sheet of glass. The paper is then carefully rubbed away so that little more than the ink remains on the glass. This surface is varnished to make what paper does remain, transparent and the image is painted from the back.

This process was in use by 1690.

Lithographic engraving

This technique lies half way between lithography and engraving. The lithographic stone is given a protective film formed by oxalic acid and gum. It is then blackened with lamp black powder to enable the engraved lines to show up. The stone is engraved in much the same way as a metal plate except that the lines are not cut so deep. Immediately the engraving is completed, the surface of the stone is flooded with linseed oil which sinks into the engraved parts giving them the power to attract greasy printing ink, while leaving the uncut protected areas unaffected. The stone is inked with a dabber rather than a roller. It

is printed in a normal lithographic press but with a soft underlay and with more than average pressure.

Litho-engraving produces a fine sharp line with blunt ends. The ink lies flat on the paper or slightly above it. There is no visible indentation and the stone does not create a plate-mark.

The process was developed in the middle of the nineteenth century, at a time when lithographic presses were able to print faster and, therefore, produce prints more cheaply than intaglio presses. Litho-engraving was widely used for letter-headings *(fig. 42)* and trade labels; it has been little used by 'fine' artists.

Monotype

To make a monotype a flat surface, glass or sometimes other materials such as card or metal, is used, and is painted with the design. A sheet of paper is then pressed on to it. When the paper is peeled off some of the paint sticks to it, forming the print. Normally only one impression is taken. The colour on the printing surface can be reinforced to allow a number of prints to be taken, but they will not be identical.

Famous users of the monotype include G. B. Castiglione, printing from copper in the

seventeenth century; Blake, printing from card in the eighteenth century; and Degas, printing from glass in the nineteenth century. Contemporary artists are attracted to the medium because of the varied textures it allows.

Nature printing

Nature printing was a process in which actual specimens, for example plants, butterflies, pieces of lace, feathers, fossils etc., were used to form the printing surface. It became popular during the second half of the nineteenth century. The technique depends on the fact that an object placed between two flat and polished surfaces, one harder than the other, will leave a detailed impression of itself in the softer. Among the surfaces used were boxwood, one piece of which was softened by steaming, and lead with copper or steel. When the latter was used the impression in the lead was electrotyped and from the relief thus obtained another electrotype was taken to form an intaglio printing plate. The blocks were inked either as relief printing surfaces so that the image stood out white and heavily embossed where the paper had been forced into the un-inked intaglio areas of the block, or as ordinary intaglio printing surfaces with the facsimile images themselves coloured.

Photogalvanography

A process that combines collotype with electrotype to produce an intaglio plate, patented by Paul Pretsch in 1854. A plate coated with light-sensitive bichromated gelatine is exposed through a negative. When wetted, the gelatine swells most where it has been least exposed. This film of varying relief with a granular surface is electrotyped, and the resulting copy electrotyped again to form an intaglio printing plate. The process, used sporadically until the end of the

nineteenth century, was finally replaced by photogravure.

Phototype

Photographically produced relief printing block, introduced by Messrs Fruwith and Hawkins in 1863, which preceded the line block. A plate was prepared with a coating of bichromated gelatine and exposed under a negative. The unexposed and, therefore, unhardened gelatine was washed away, and the remainder electrotyped. The copper thus deposited over the surface, following the depressions formed by the lines of the image, created a relief block.

Process print

A term used loosely, and often derogatively, to refer to photo-mechanical techniques in any of the relief, intaglio and photographic processes.

Woodburytype

An adaptation of the Carbon print process by W. W. Woodbury (1834–85) to provide mass-produced unfadeable alternatives to albumen and collodion prints. Light sensitized gelatine is mixed with carbon pigment and spread thickly on to a glass plate. Exposed under strong light through a negative, it emerges as a film thickest in the darkest areas and thinnest in the lightest. A mould is made by pressing the gelatine into sheet lead under enormous pressure. Into this mould is poured a mixture of water, pigment and ordinary gelatine, which dries to form the Woodburytype. Although at first sight it looks like a photograph, it does not have any light sensitive material in its final form. It is an image formed only by pigment suspended in gelatine.

Suggestions for further reading

There are hundreds of books on prints, dealing with the subject from many angles and aimed at different kinds of reader. This brief selection aims to cover most of them but it is meant for the student and curious layman rather than the expert or the scholar. Although the books are grouped under two main headings many of them could be included under both. The section headed 'History and appreciation' is limited to general books but all of those listed have bibliographies themselves leading the reader to more specialized works.

Technique

General

British Council, *The processes of printmaking*, catalogue to an exhibition organized by Julia Atkinson with the Printmakers Council, 1976
An account in 16 pages of all techniques used by contemporary printmakers with elucidating 'action' photographs.

Felix Brunner, *A handbook of graphic reproduction processes*, 1962
A clear explanation of techniques with enlarged reproductions of the marks made by the different processes, arranged to bring out the distinguishing qualities of apparently similar media.

Harold Curwen, *Processes of graphic reproduction in printing*, 3rd ed., 1963
Particularly good for photo-mechanical techniques.

Gabor Peterdi, *Printmaking methods old and new*, New York, 1959
Techniques described for the printmaker; particularly good on unusual combinations.

Printmakers Council, *Handbook of printmaking supplies*, ed. by Silvie Turner, 1977
As well as listing suppliers of printmaking materials, it gives details of print publishers, galleries, workshops, organizations and societies.

Erich Rhein, *The art of printmaking: a comprehensive guide to graphic techniques*, 1976

Explanations of manual printmaking techniques aimed at the art teacher, student, and amateur artist.

Paper

Dard Hunter, *Papermaking: the history and technique of an ancient craft*, 2nd ed., New York, 1947
Still the standard introduction; available in many public libraries.

Relief

John Jackson, *A treatise on wood-engraving historical and practical*, 1838, 2nd ed., 1861
By a practising wood-engraver; still the most detailed book on the subject for the period it covers.

John O'Connor, *The technique of wood engraving*, 1971
Well illustrated account of the technique with a list of suppliers of the necessary materials.

Michael Rothenstein, *Relief printing: basic methods: new directions*, 1970
Gives a well-illustrated interesting mixture of traditional and photo-mechanical methods aimed at the art student but also of general interest.

Intaglio

Anthony Gross, *Etching, engraving and intaglio printing*, O.U.P., 1970
Presents technical and historical information in a personal and readable way.

S. W. Hayter, *New ways of gravure*, O.U.P., 1966
A personal view of contemporary practice set in an interesting historical perspective; goes into viscosity colour printing in detail.

E. S. Lumsden, *The art of etching*, New York, 1924
Reprint Dover edition, 1962
Still the standard etching instruction manual, with many recipes for grounds, mordants etc. and a section on printing papers; plus a historical survey and comments from contemporary etchers.

Lithography

David Cumming, *Handbook of Lithography*, 1932
Still the standard manual among printers.

Stanley Jones, *Lithography for artists*, O.U.P., 1967
A short, practical account of all aspects of the technique including photo-lithography.

Renée Loche, *Lithography*, Geneva, 1971
From the 'Craft & Art' series. A clear account of the technique, concentrating on images drawn on stone.

Alois Senefelder, *A complete course of lithography*, New York, 1968
Reprint of the first English edition published in 1819.

Screen printing

J. I. Biegeleisen, *Screen printing*, New York, 1971
Intended as a guide for the professional artist, designer and craftsman but easily understood by the general public.

Tim Mara, *The Thames and Hudson manual of screen printing*, 1979
It contains clear practical information ranging from the construction of do-it-yourself equipment to the use of the most sophisticated machines on the market. It is well illustrated with diagrams, 'action' photographs, and reproductions of screen prints accompanied by descriptions of their manufacture.

History and appreciation

R. M. Burch, *Colour printing and colour printers*, 1910
Still the most comprehensive historical review of printmaking from this point of view. Available in major public libraries.

Pat Gilmour, *Modern prints*, 1970
Concise and readable survey of printmaking from about 1900. Over 130 reproductions in 160 pages.

Pat Gilmour, *The mechanised image, An historical perspective on 20th century prints*, Arts Council of Great Britain, 1978
Based on an exhibition, it is an influential discussion of the techniques, uses and content of twentieth-century prints in their historical context; includes a concise glossary of printmaking terms.

Richard T. Godfrey, *Printmaking in Britain: a general history from its beginnings to the present day*, 1978
Just what the sub-title claims.

Antony Griffiths, *Prints & Printmaking*, British Museum Publications Ltd., 1980
Lively general survey (including sections on technique) accompanied by unusually illuminating reproductions, many of them actual size and shown with the printing surface.

Arthur M. Hind, *A history of engraving and etching*, 3 ed. 1923. Dover reprint 1963
Information-packed survey with an appendix showing at a glance who worked where, when and how, and who was influenced by whom; still used widely by museum curators etc.

William Ivins, *Prints and visual communication*, 1953
Authoritative but personal history of prints approached from their role in society.

William Ivins *How prints look*, 2 ed., New York, 1958
A collection of photographically enlarged details of prints, explaining why different prints have the appearance they do.

Felix H. Man, *Artists' lithographs, a world history from Senefelder to the present day*, 1970
Useful for its 200 or so reproductions, many in colour.

A. Hyatt Mayor, *Prints and people, a social history of printed pictures*, 1971
Historical survey of the subject which questions the reasons for making and looking at prints.

Andrew Robison, *Paper in prints*, National Gallery of Art, Washington 1977
Deals with the aesthetic role of paper in Western prints: surface qualities, colours and proportions.

Michael Twyman, *Lithography 1800–1850*, O.U.P., 1970
Scholarly section on technique combined with an account of the growth of its use.

Geoffrey Wakeman, *Victorian book illustration: the technical revolution*, Newton Abbot, 1973
Particularly useful for obscure nineteenth-century photo-mechanical techniques.

Herman J. Wechsler, *Great prints and printmakers*, New York, 1967
Sumptuously produced book valuable for its illustrations arranged by technique, aimed primarily at the would-be collector.

F. L. Wilder, *How to identify old prints*, 1969
Brief explanations of techniques with a general historical survey. Approached from the collector's point of view, with details of the most desirable impressions of prints by major masters and information on the more deceptive copies and forgeries.

C. Zigrosser and C. Gaehde, *A guide to the collecting and care of original prints*, 1966
Concise book which raises questions of interest to all who enjoy prints.

Technical terms and abbreviations

Ad vivum: Literally, drawn from life, from nature; most commonly found on portraits indicating that the subject sat for the portrait.

After: Its use indicates that the engraver has engraved a work by another artist: E.g. Mezzotint by William Barney after Gainsborough indicates a mezzotint engraved by Barney after a drawing or painting by Gainsborough.

Artist's proof, A.P.: Proofs outside the edition reserved for the artist. These proofs are sometimes identified by Roman numerals.

Blind proof: An uninked impression made by placing a dampened sheet of paper on an engraved plate and passing both through a press.

Bon à tirer, B.A.T.: Inscription by the artist indicating that the printer should take this particular impression as his guide for the edition.

Cancelled impression: An impression from a plate or stone after the intended edition has been taken. The artist may indicate that the plate or stone is cancelled by defacing it in some way, such as drilling holes in it or striking a line across it.

Chop: Embossed seal impressed in the paper by the printer and/or publisher.

Collector's mark: A mark, often stamped, indicating the owner of a print. These marks can help trace the provenance of works on paper. They are often referred to by Lugt numbers. These are numbers in the catalogue compiled by Frits Lugt, *Les Marques de collections, Dessins–estampes*, Amsterdam, 1921.

Composuit, comp.: Composed, designed.

Counter proof: A print, not from the plate, but made by passing a dampened sheet of paper through a press in contact with a freshly printed impression. A counterproof shows the image the same way round as it is on the plate and therefore helps the printmaker during the progress of the work.

Cum privilegio: Indicates that the owner of the original drawing or painting has given the engraver or publisher the right to reproduce.

Delineavit, delin., del.: Drew.

Edition: The number of prints made from one design. A print may be published in a limited or unlimited edition. If the edition is limited this will normally be recorded on the print in pencil. For example a print numbered 25/70 indicates, in theory, that this particular print is the twenty-fifth impression from the plate of an edition limited to seventy impressions. In practice prints are numbered as they are signed and this is rarely done in the order they are printed.

Épreuve d'artiste:	See Artist's proof.
Excudit, excud., exc.:	Brought out, produced; used to indicate the publisher.
Fecit, fec., fe., ft., f.:	Made; implying the printmaker.
Fecit aqua fortis:	Etched.
Figuravit:	Represented; generally refers to a drawing made for the engraver after the painting being engraved.
Hors commerce proof:	Proof outside the commercial edition. These are often samples used in selling and may become damaged through handling. As with artist's proofs they are sometimes identified by Roman numerals.
Impression:	The term used to refer to any print taken from metal, stone and wood. By association it is often used to refer to a screen print although technically it is not an accurate description.
Impressit, imp.:	Printed. If written in pencil after the artist's signature it indicates that the artist himself has printed the work.
Incisit, inc.:	Engraved.
Invenit, inv.:	Conceived; used to indicate the original artist, originator of the image.
Late impression:	A self-explanatory description. In the intaglio processes, late impressions can be detected by the weak printing resulting from the exhausted state of the plate.
Lith:	Drawn or painted on stone; used of both the draughtsman and the printer of lithography.
Lith by:	Lithographed by; implying the printer.
Margins:	The 'margins' are the paper beyond the platemark or in the case of relief, planographic and stencil prints, beyond the image itself. Margins are rarely found on prints made before the eighteenth century, hence the supposition that they were cut off before publication. A print with 'thread margins' has just enough margin to show the platemark while 'full margins', implies that the paper is untrimmed. 'Wide margins' implies something between these extremes.
Pinxit, pinx., p.:	Painted.
Proof:	The term comes from 'proving' the printing surface. Proofs are individual impressions produced, except in the case of artist's proofs (q.v.), before the printing of the published edition. They may be trial proofs taken by the artist to see how the design is progressing during the production of the printing surface or printer's proofs taken to ascertain how the plate should be inked and on what paper it should be printed. Sometimes, however, the term 'proof' is used incorrectly with the aim of increasing the market value of an impression.
Published as the Act directs:	A printed inscription referring to one of the many acts of Parliament from 1735 dealing with the copyright of engravings.

Pull:	See Impression.
Remarque proof:	So called because of the small sketches (remarques) on the margin of the impression. A form of doodling on the plate during the progress of the work, normally removed before printing of the edition. A fetish was made of this kind of decoration towards the end of the nineteenth century.
Reprint:	Properly applies to a print from a second or a later edition from a plate that has not had additional work on it.
Restrike:	Restrike from a cancelled plate or stone.
Reworked:	The number of good impressions that can be taken from an intaglio plate is limited. When signs of wear appear the worn parts are sometimes re-etched or re-engraved. This is frequently done before reprints are taken.
Sculpsit, sculpt., sculp., sc.:	Engraved.
Signed by the artist:	This normally implies that the plate, stone or block has been signed by the artist and that it is likely to be an original work of art by him. If this is the case the signature is usually printed in reverse. To prevent this the artist must either go through the laborious process of imitating his signature the wrong way round or use some reversing process such as transfer lithography to transfer his design to the printing surface.
Signed in facsimile:	This means that the signature has been copied in reverse on the plate, stone or block by a professional engraver, lithographer etc. so that it appears on the print the right way round. Facsimiles of the artist's signature normally occur only on reproductive prints.
Signed in pencil by the artist:	This normally implies that the print is an original work of art by the artist. The practice of signing prints in this way grew up in the nineteenth century. The added value attached to prints signed in this way led to the practice also being adopted for reproductive engravings, a higher price being asked for those bearing the painter's as well as the engraver's signature. The painter's signature was intended to indicate that he had approved the reproduction. This practice is still followed sometimes with photo-mechanical reproductions.
State:	A particular stage in the development of a work. Any alteration to the printing surface, after a proof has been taken, involves the creation of a new state.

Index